Everyday Signs of Life

⊷ THE ARGIAN PRESS ⊶

19 Tilton Avenue, Oneonta, New York 13820 USA

©2010 Robert M. Lipgar

ISBN 978-0-9820821-9-5

Digital imaging services provided by Spectral Master Digital Imaging, Inc.

Typesetting and design by Sir David Hayes

Third Printing

Printed in the United States of America

Everyday Signs of Life

ROBERT M. LIPGAR

I photograph where I find myself and I find myself where I photograph.

ACKNOWLEDGEMENTS

For their encouragement and support during the development of this book, I wish to thank June and Edmond Freeman, Leonard Garr, Tim Golbuff, Karen Granda and John Mroveic, Ann Kaplan, Larry Kleiman, Shelley J. Korshak, Bob Lemkowitz, Veda and David Levin, Nancy and Ken Marks, Tamara and Jeffrey Roth, Pamela Wardwell, Louis Williams, and Susanna White.

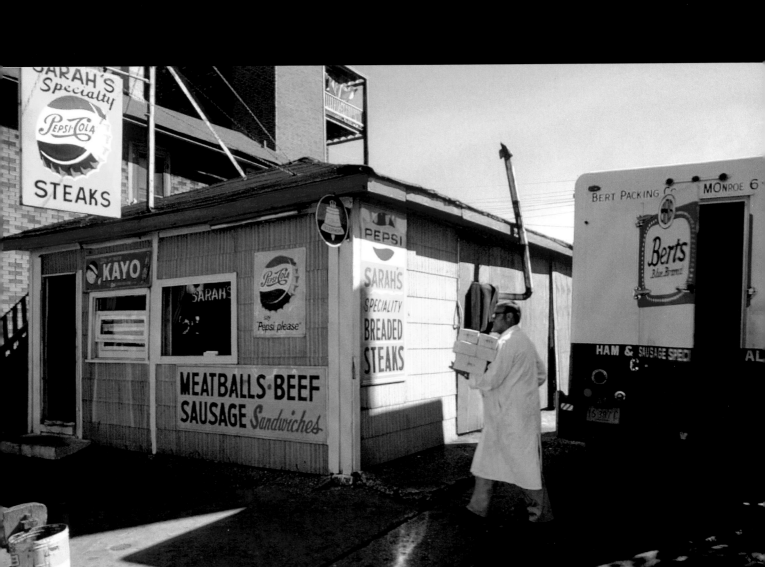

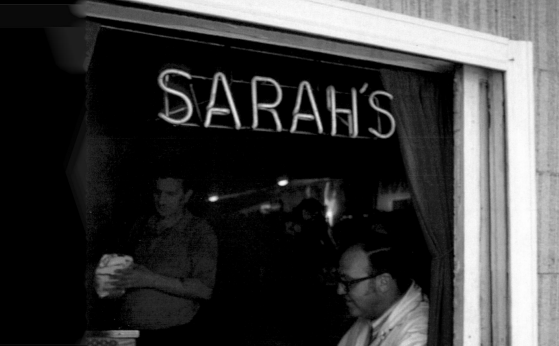

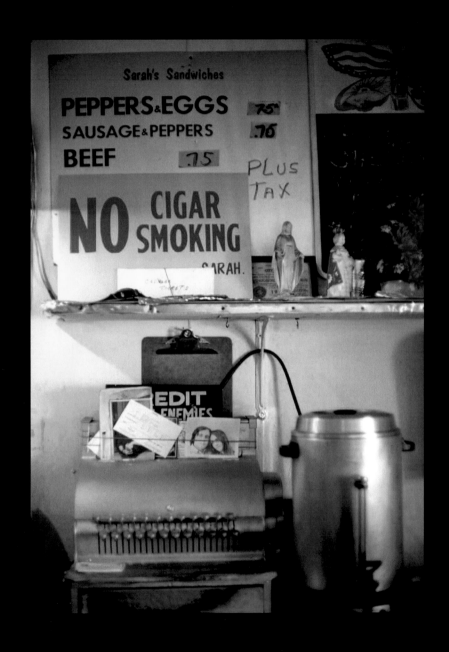

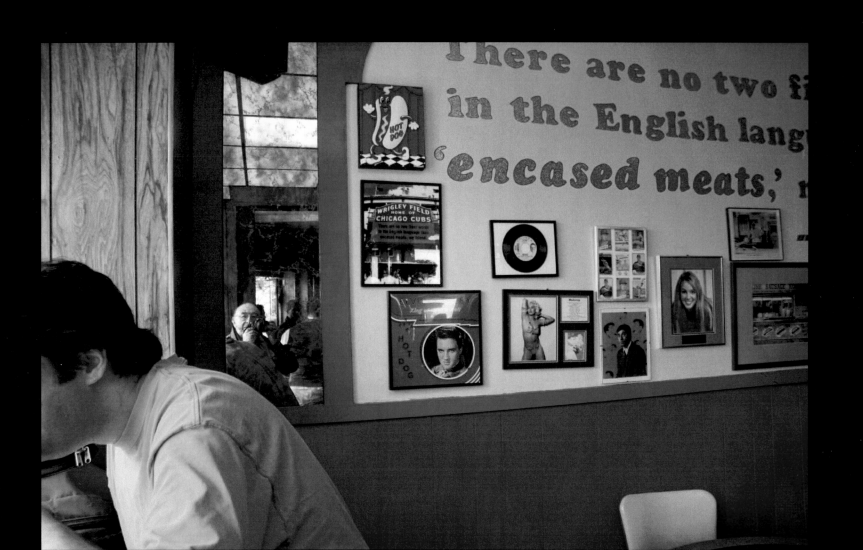

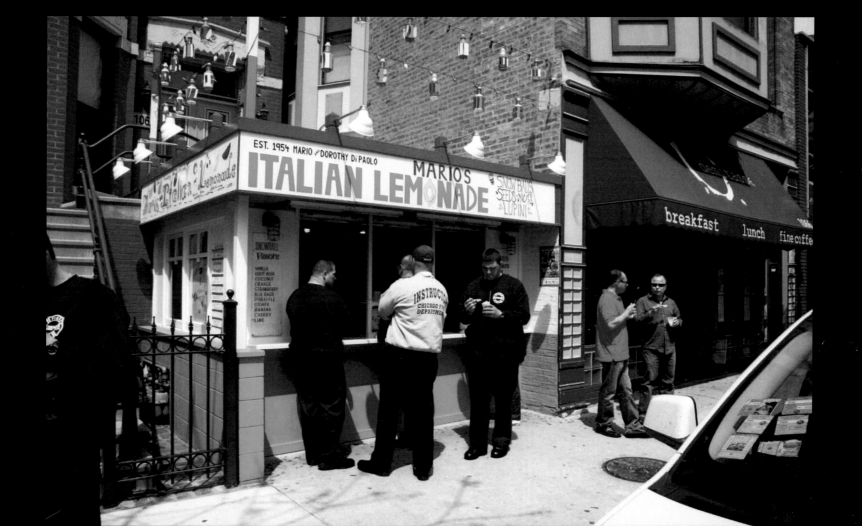

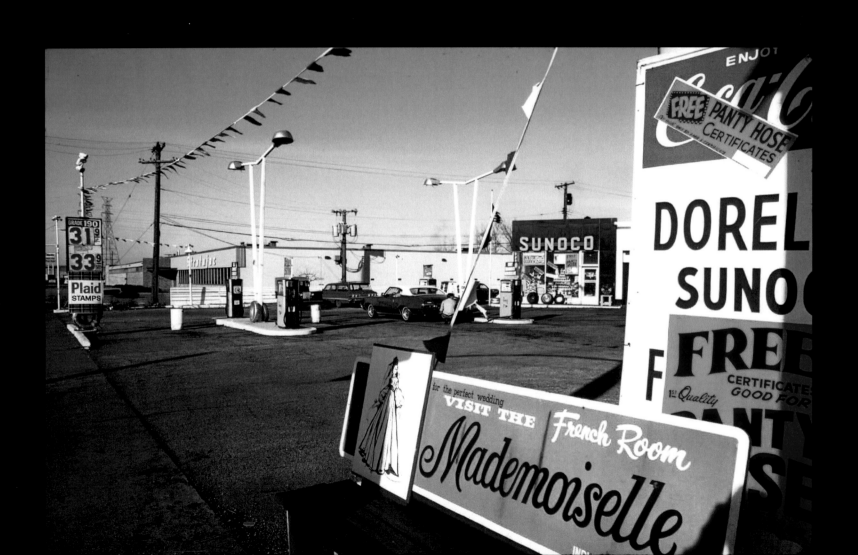

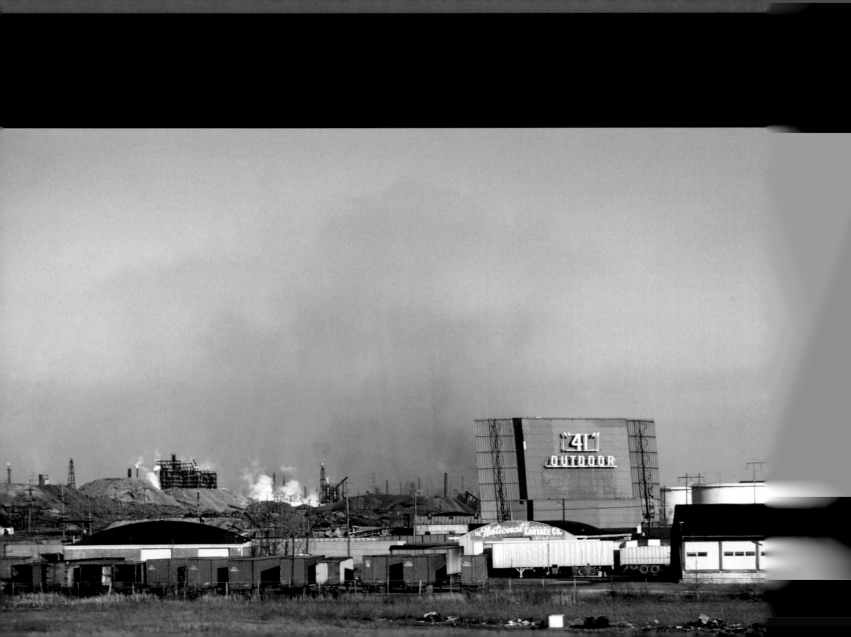

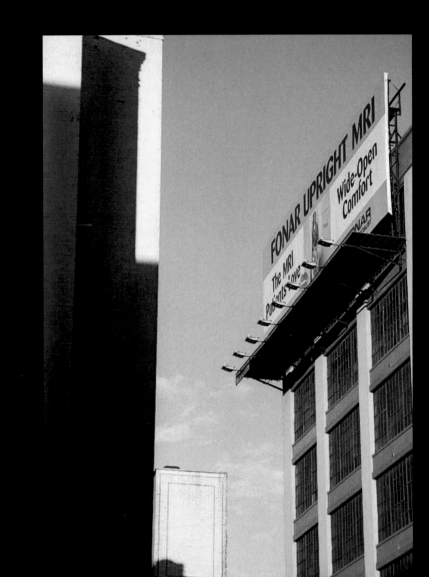

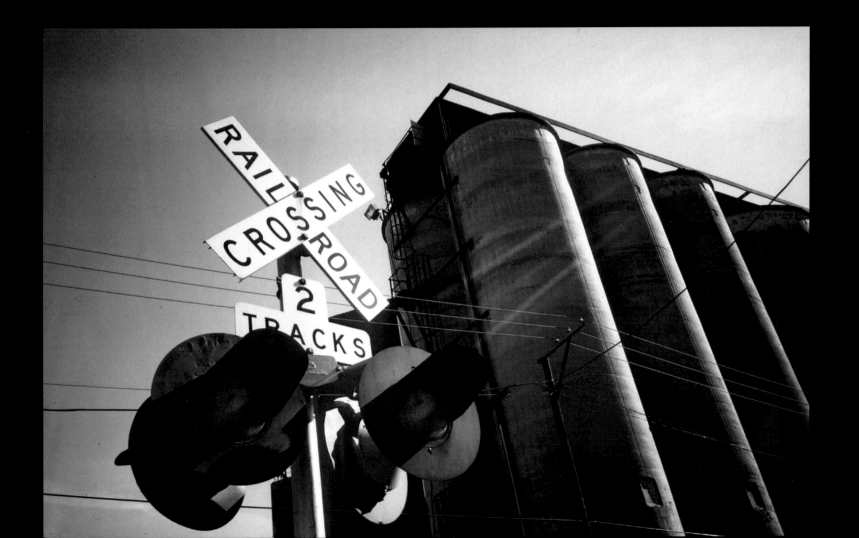

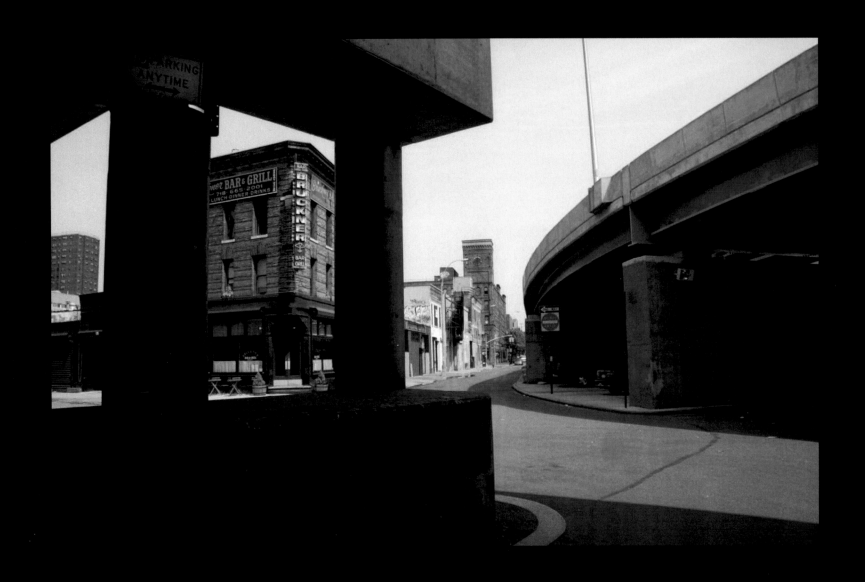

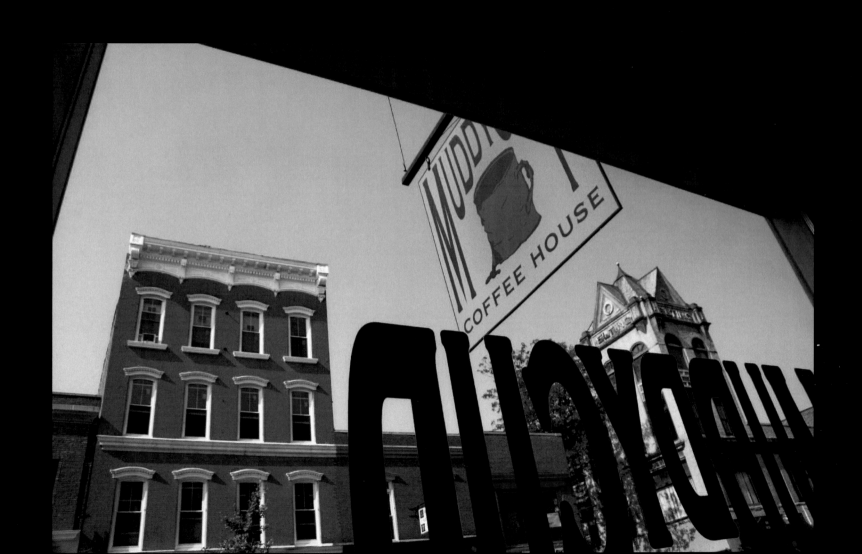

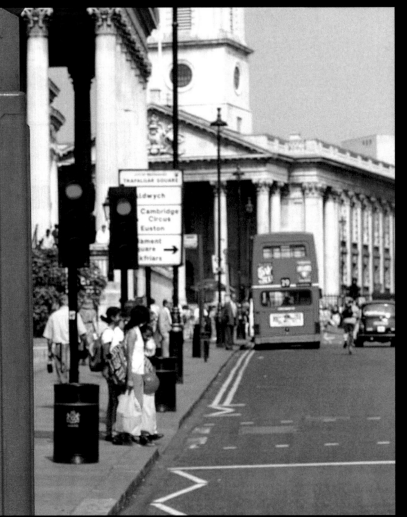

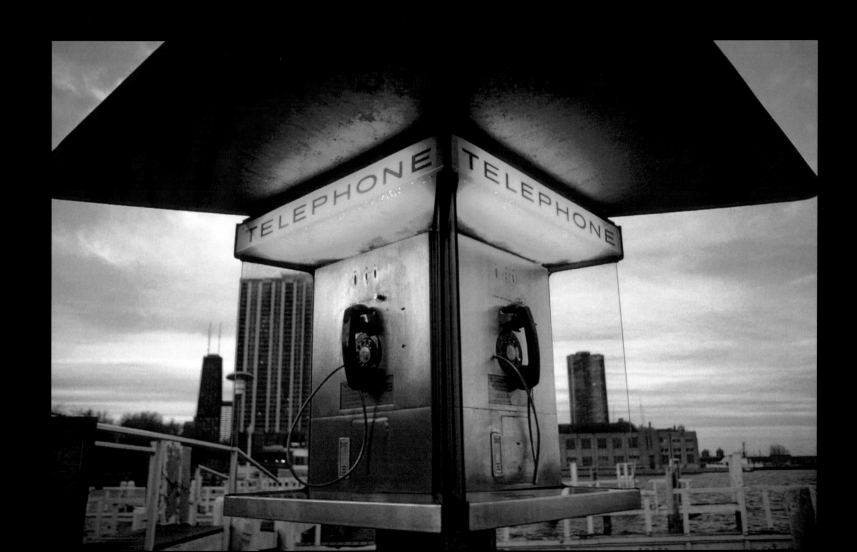

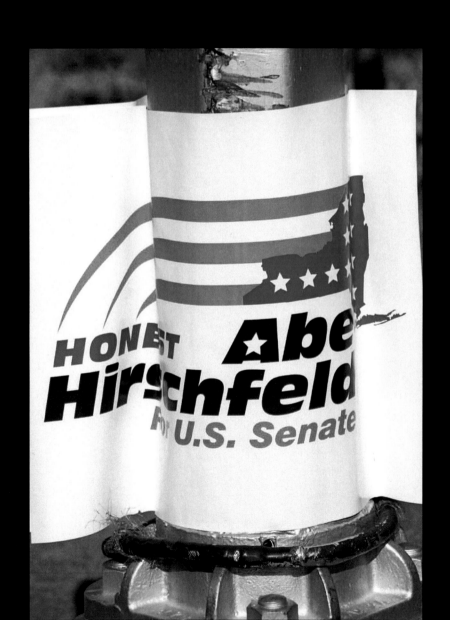

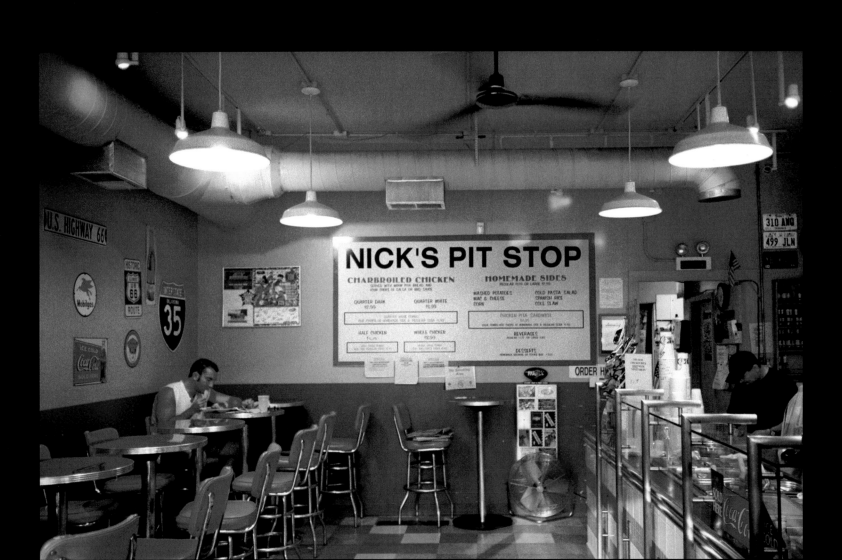

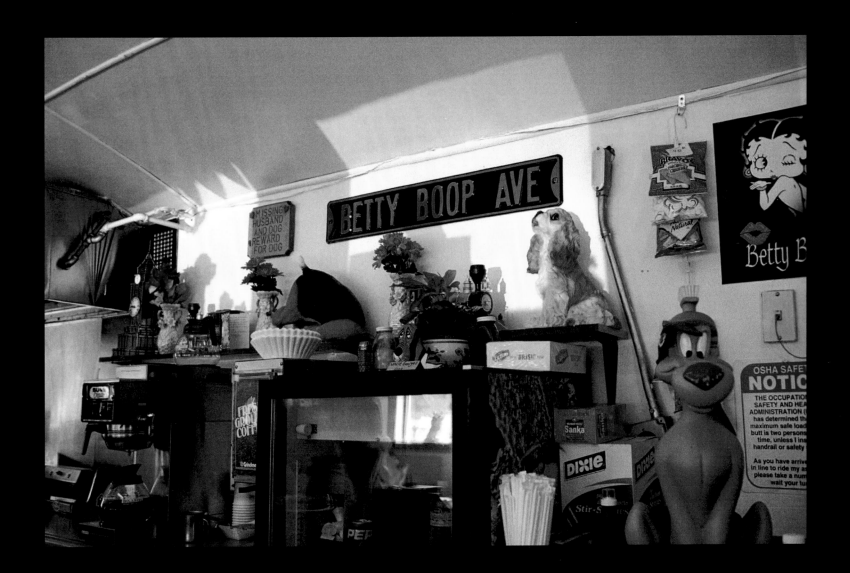

On The Road

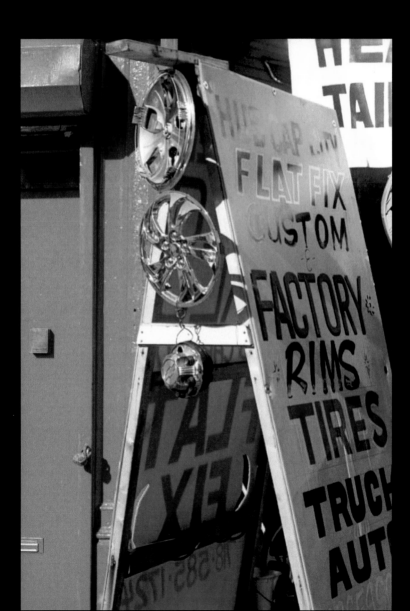

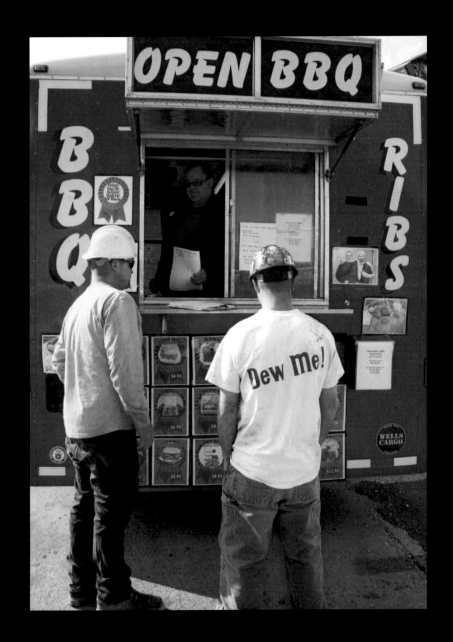

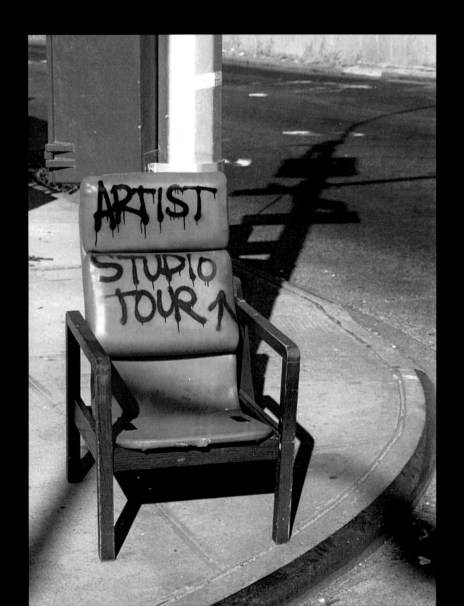

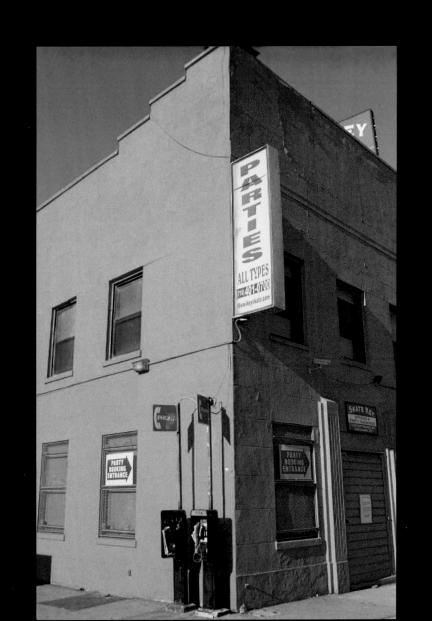

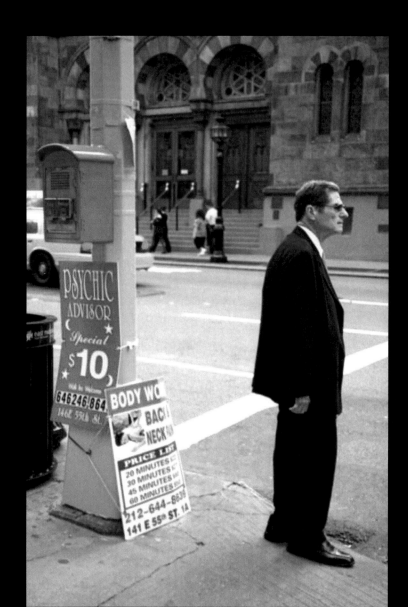

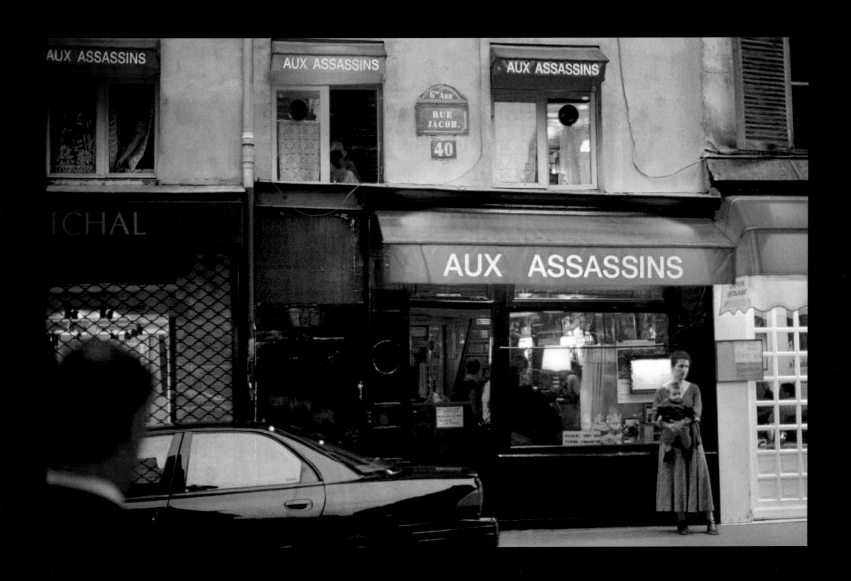

Paris

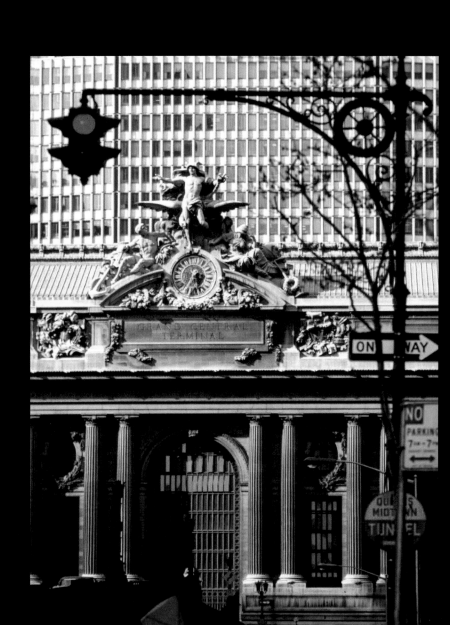

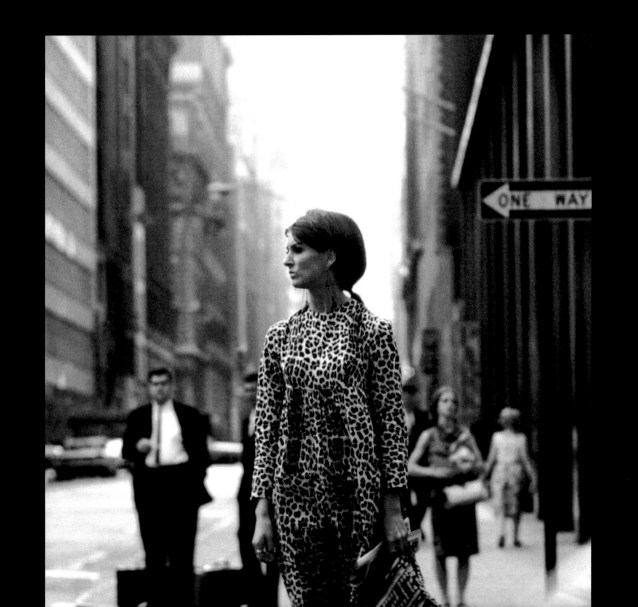

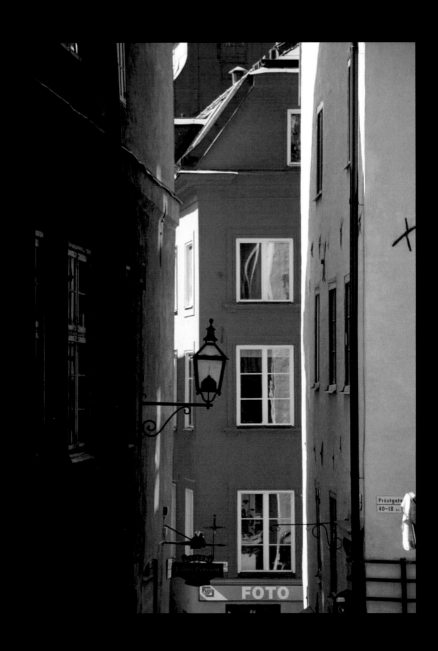

Old Stockholm

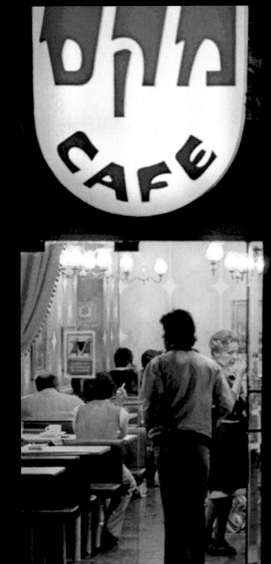

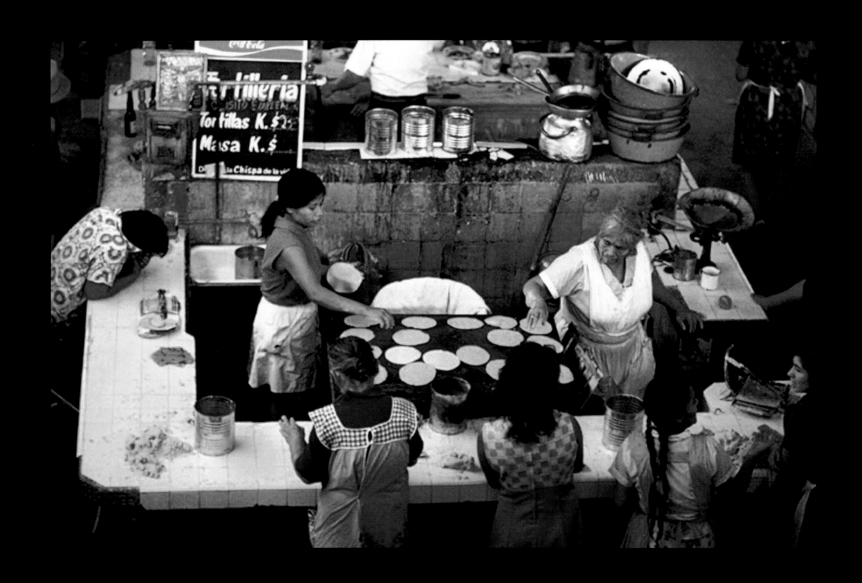

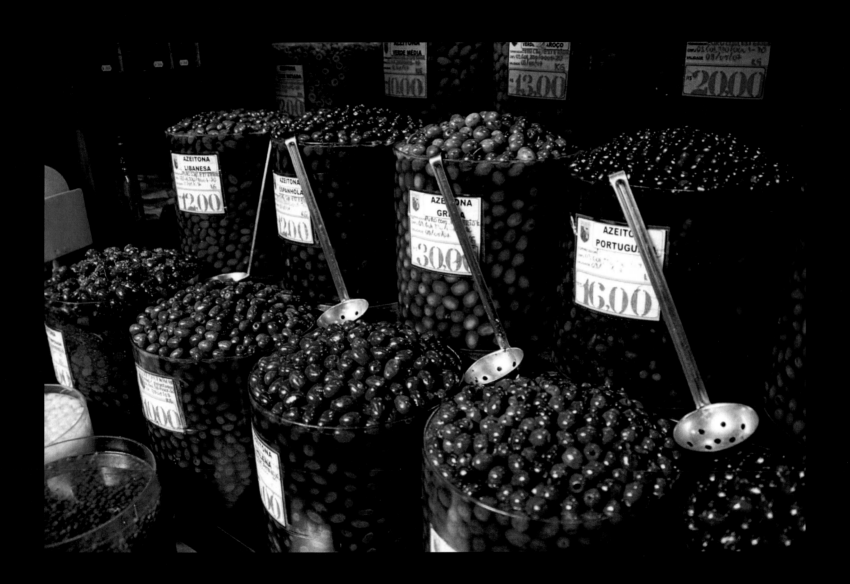

São Paulo

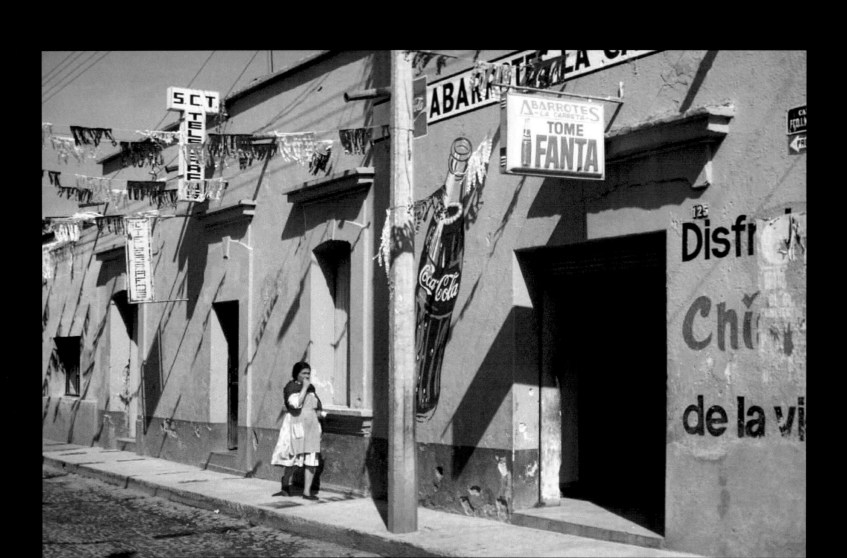

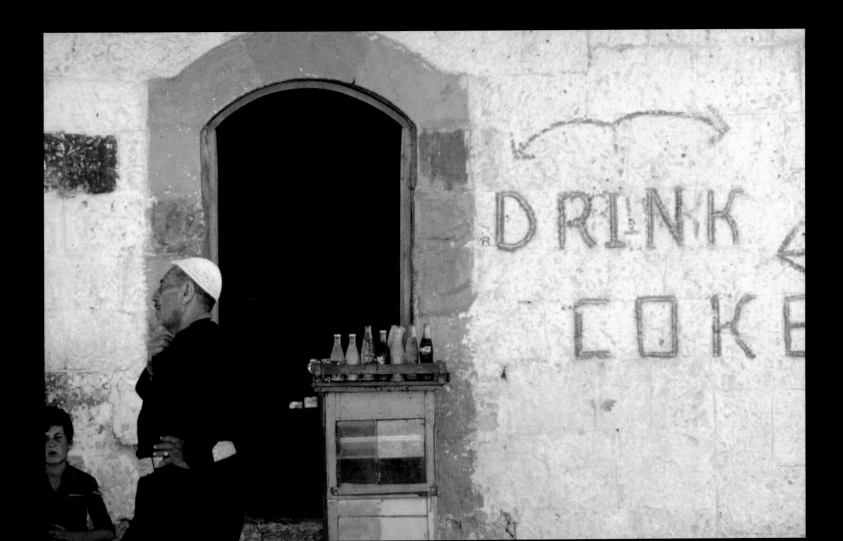

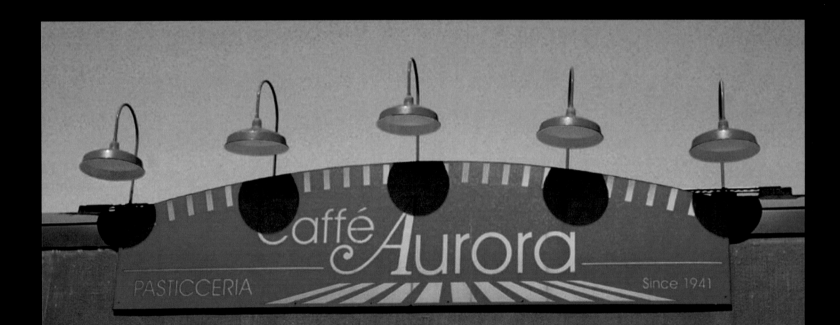

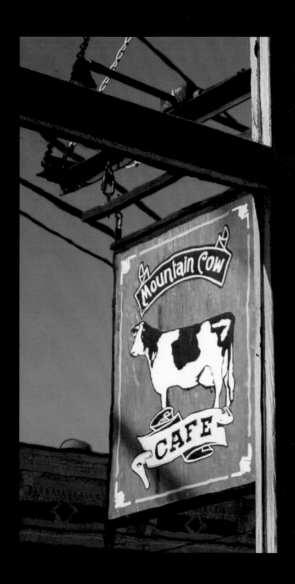
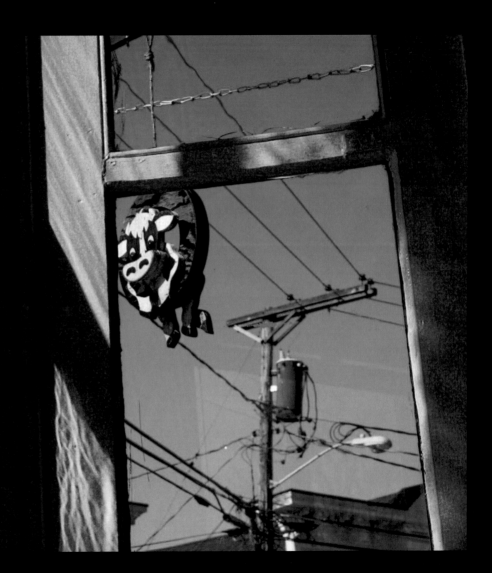

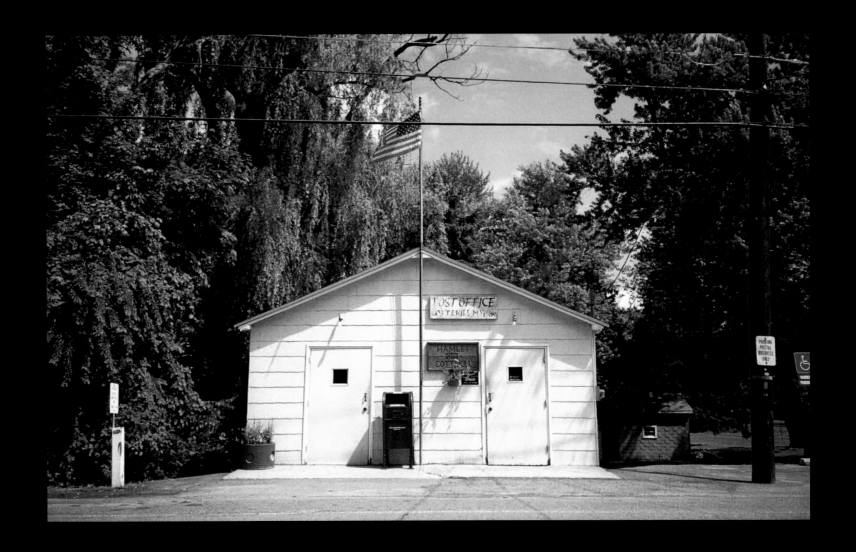

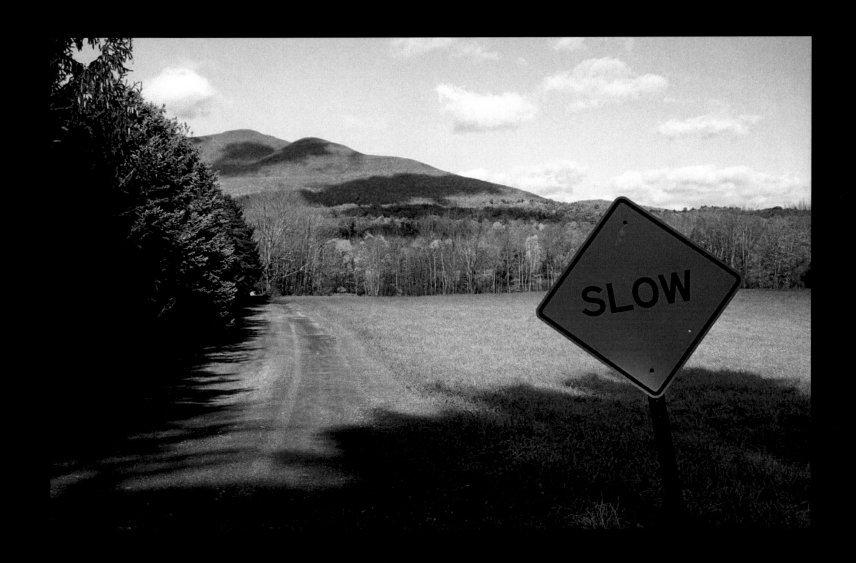

Kripplebush, New York

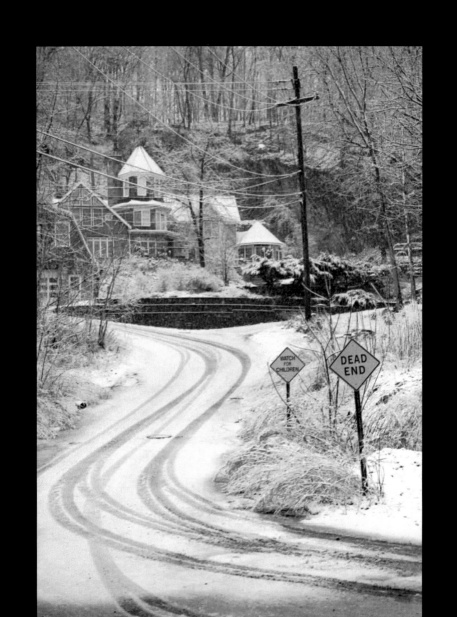

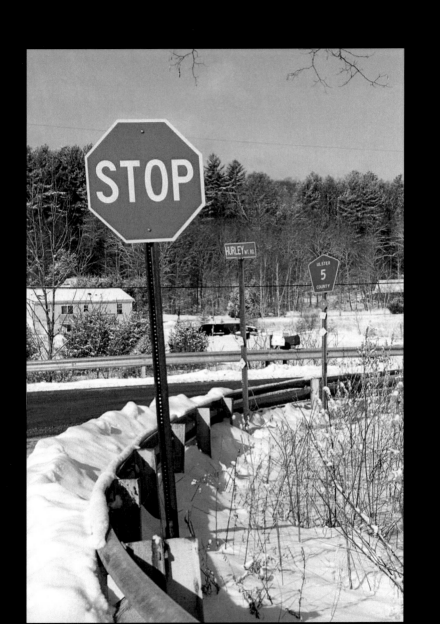

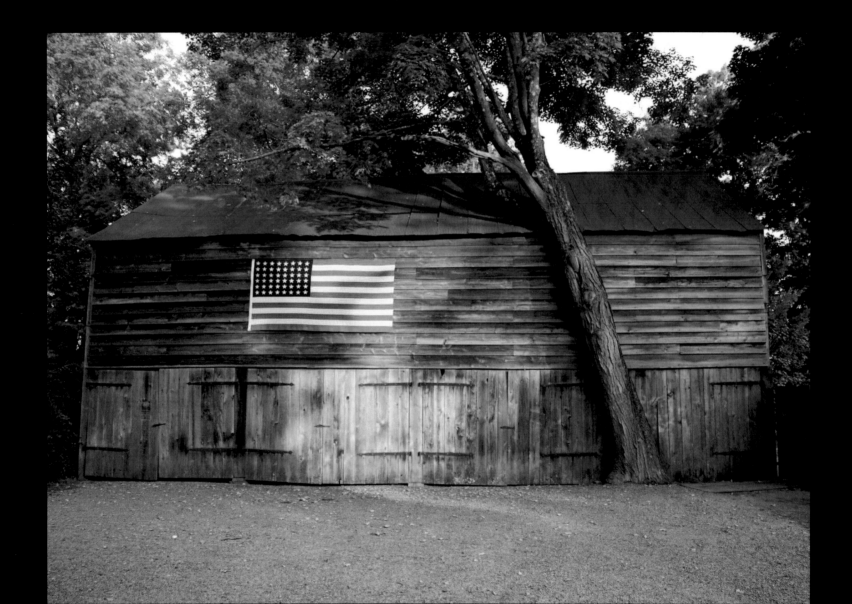

ABOUT THE PHOTOGRAPHER

Robert Lipgar, born and raised in Kingston, NY, was introduced to photography at a young age assisting his father, A. H. Lipgar, Hudson Valley's leading photographer from the 1920's through the 1950's. After a decade-long apprenticeship with his father, Bob entered Hamilton College to further his creative studies and combined them with the study of psychology. Following Hamilton, he relocated to Chicago where he earned a doctorate in clinical psychology at the University of Chicago.

In Chicago, Bob established himself as an exhibiting photographer as well as a distinguished leader in clinical and group psychology. Among his many photography exhibitions were shows in Chicago at the First National Plaza, the American Bar Association, the Chicago School of Professional Psychology, Two Illinois Center, the American Jewish Congress, the American Friends of the Hebrew University of Jerusalem, and the University of Illinois. His work has also been exhibited to critical acclaim in Wisconsin, Ohio, and at the Museum of Natural History and the Southeastern Arkansas Arts & Science Center in Arkansas. His photographs are included in many collections in the United States, Canada, and internationally.

Bob, now home again resettled in Rhinebeck, New York, is inaugurating a second generation of *Lipgar photography* in the Mid-Hudson Valley. Bob is an active member of the Woodstock Artists Association and Museum and the Arts Society of Kingston. In 2006, he was awarded the Leilani Claire Prize for Photography by WAAM, and his work has also been featured in the Catskill Mountain Region *Guide* magazine.

In putting this book together, I felt like a circus master. I found myself trying to balance three rings of graphic activity—color, composition, and context. If you find these images entertaining and evocative, then I've done my job. These pictures hold many memories for me and I hope they will stimulate your thoughts and feelings of times and places you've been or might wish to visit and revisit.

www.lipgarphotography.com